My Sleeping Beauty

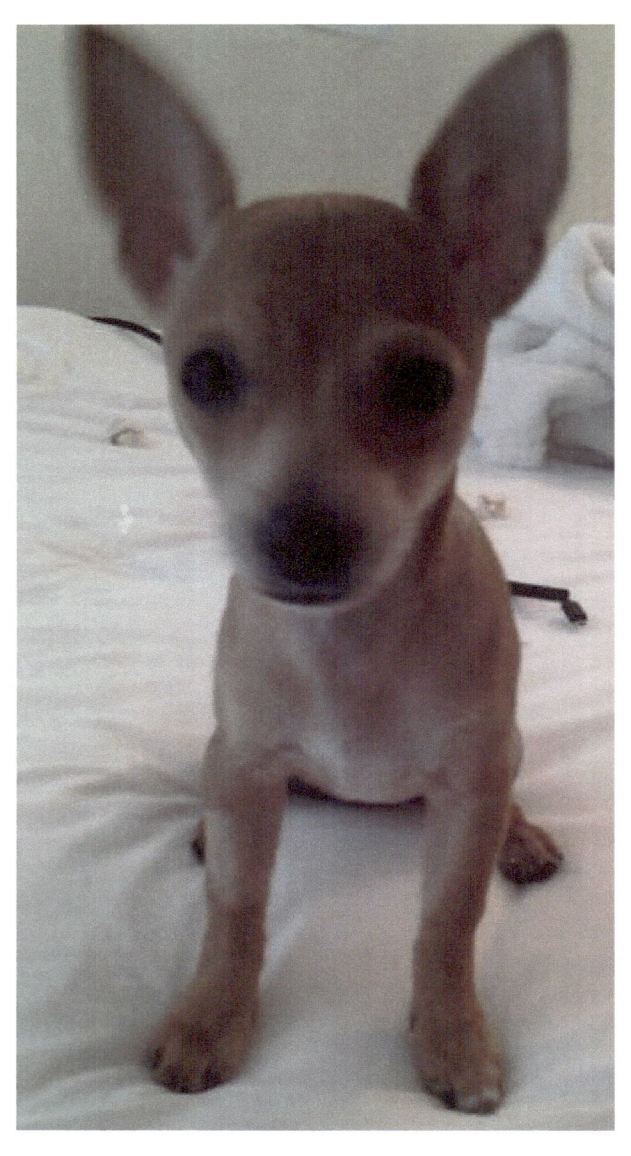

Wide-Eyed Girlie Girl

Munching on her chewy toy

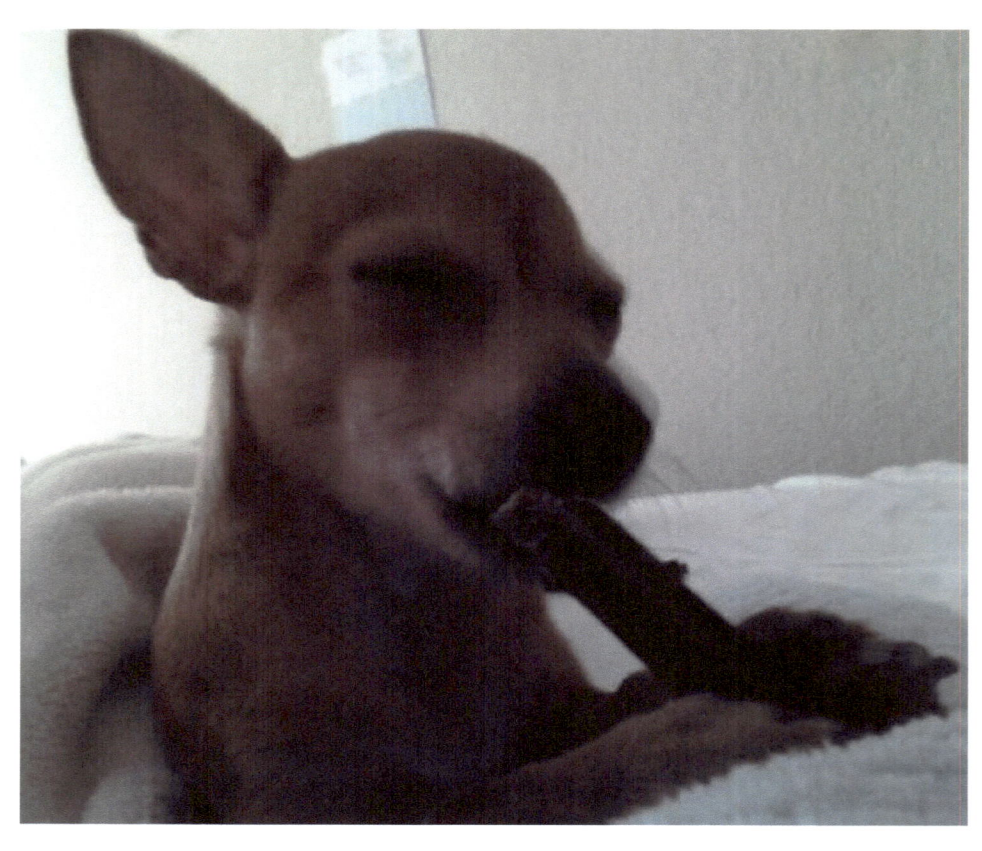

Oooh so good!

Contented Bliss

Sweet Baby on my arm

Enjoying the view: curly q's on her bottom

~ Sweet Dreams ~

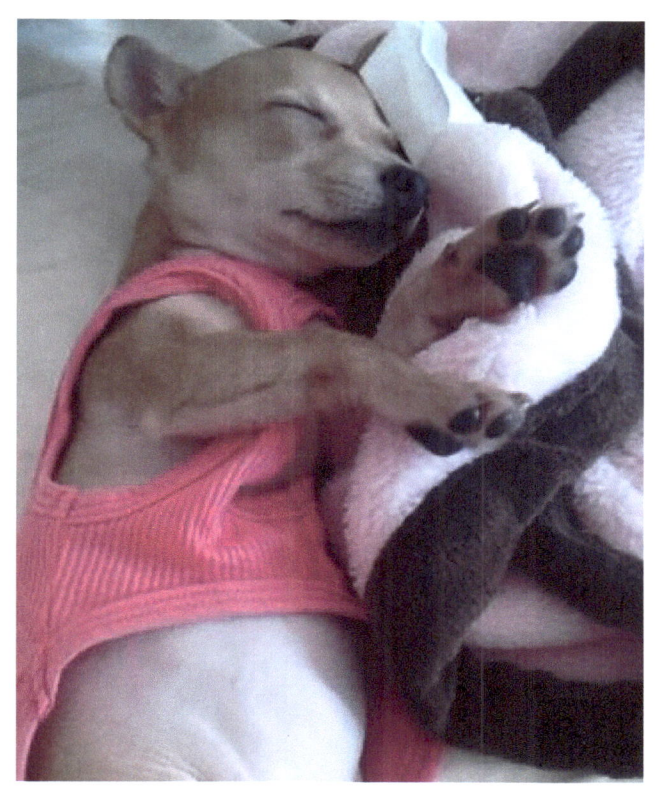

Such a sweetie

Teeny Tiny: puts Collette into perspective

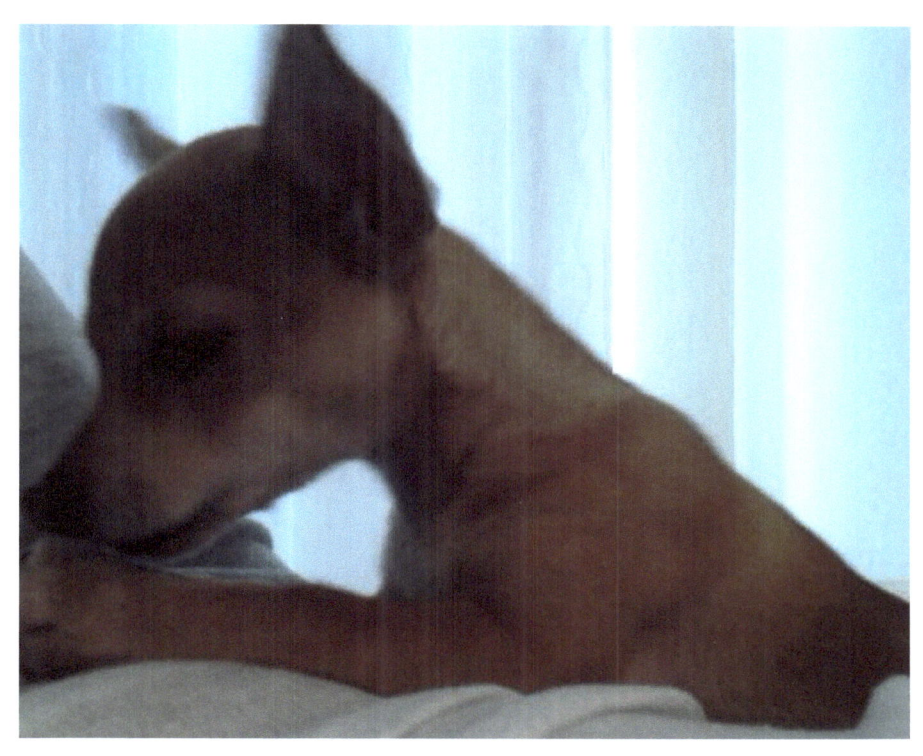

Looks like she is praying

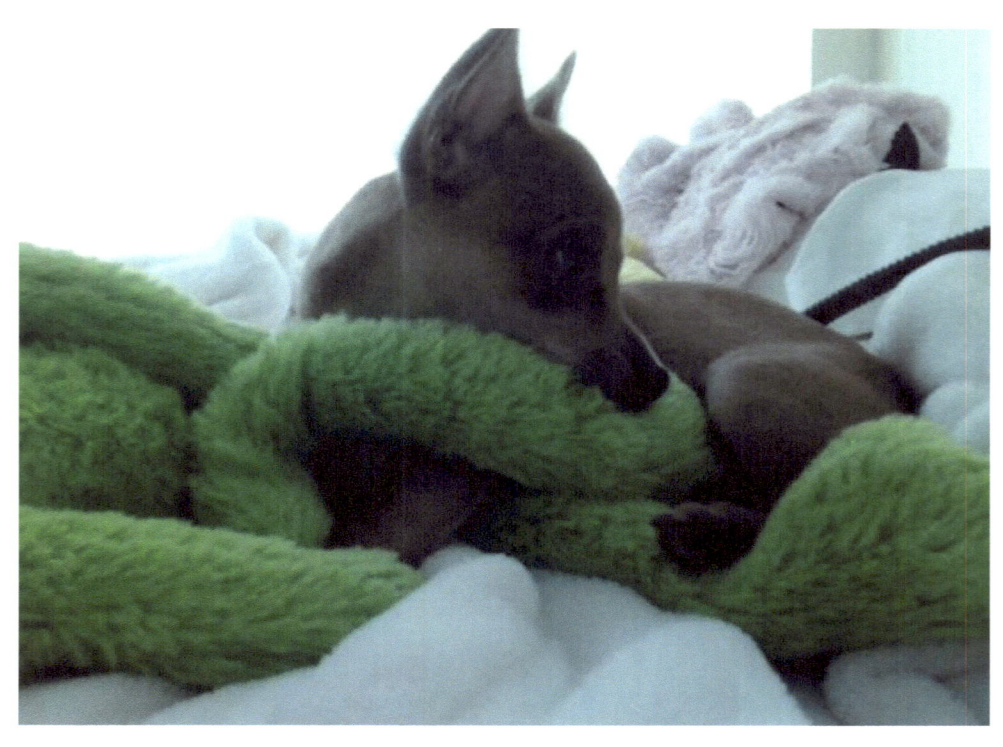

Playing with her green stuffed animal, frog

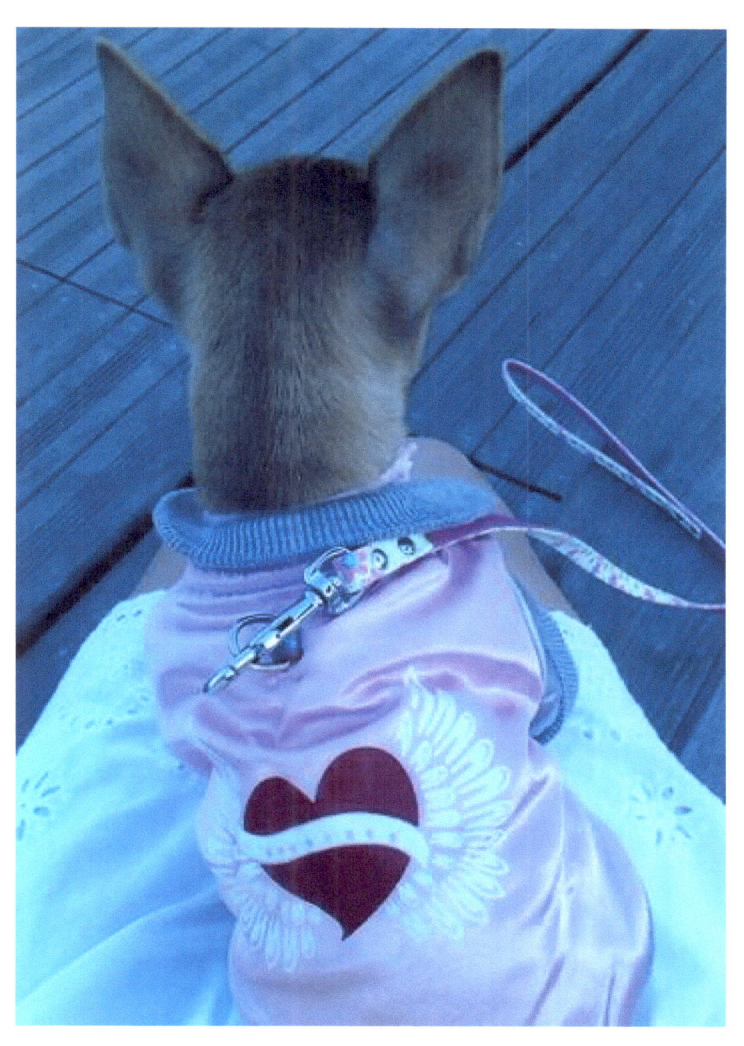

My baby has wings

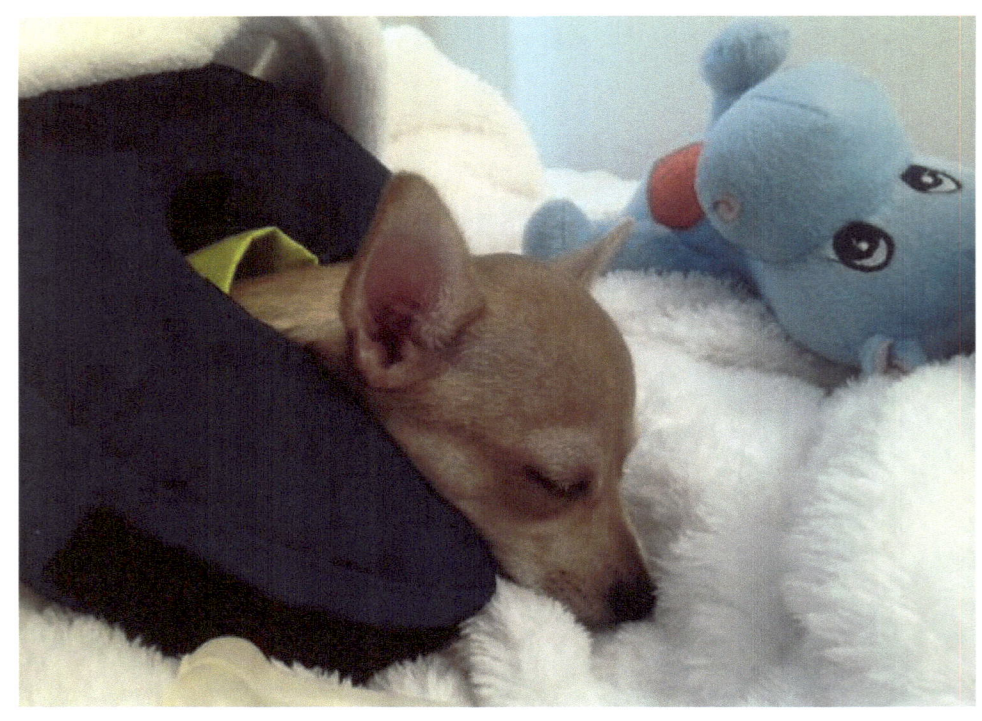

Poor thing, recuperating from her surgery

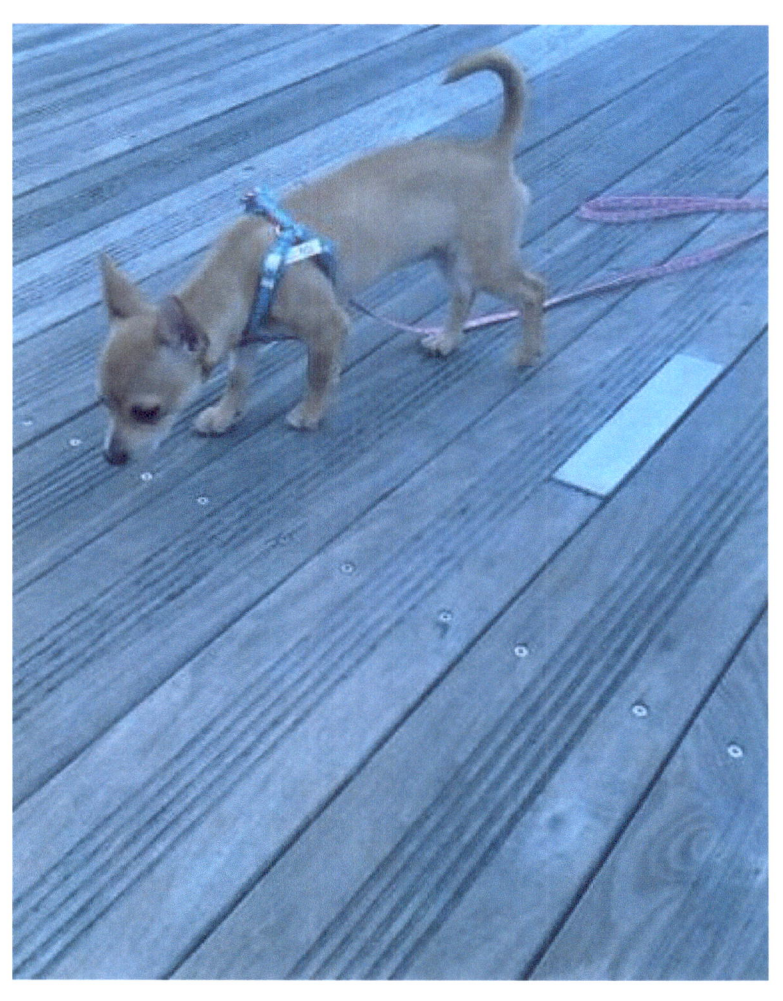

Taking a stroll on the dock

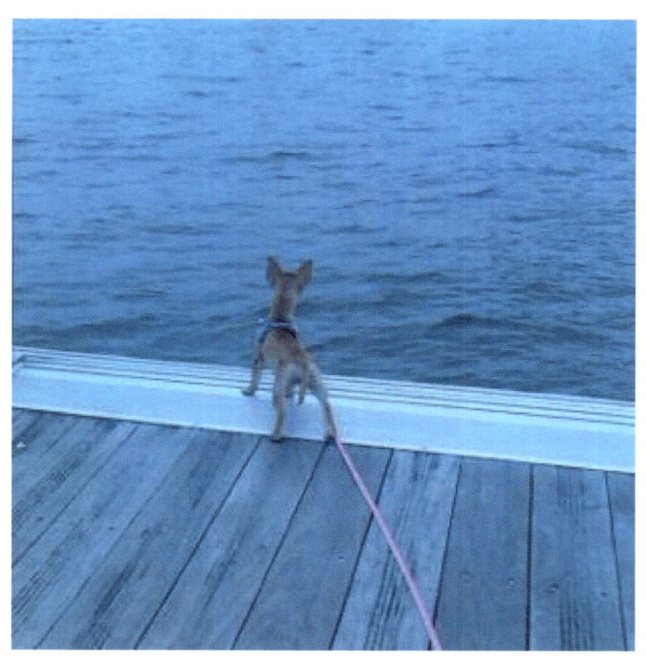

Looking out toward the horizon

Just woke up

Hmmm…

Hand-in-hand

One of her usual sleeping positions

~ My Pretty Collette ~

Ever the watchful pup

She delights in the simplest of things

She makes my life

worthwhile

enriching it with vivid hues and brilliant colors

Her love of life

The playfulness and cheeriness

That which encompasses every puppy

But hers which is uniquely, Collette's

Makes my life fully complete

And in this one way

I express my gratitude and unlimited love

To my dearest, sweetest Collette

The meaning behind the name, Collette:

People of Victory

There was also once a Saint Colette:

Whom is the Patron Saint of women seeking to conceive, expectant mothers and sick children (according to: wikipedia.org)

Whether having a pet or a child, always treat them with a great amount of love, kindness and generosity. Do right by them and what you will receive from them will be ten-fold

(in mental health and spirit)

www.ingramcontent.com/pod-product-compliance
Lightning Source LLC
Chambersburg PA
CBHW041624180526
45159CB00002BC/1000